W9-BFC-132

ON THE
·S·P·O·T·
GUIDES

DRAWING CARTOONS

STUART TROTTER

·OUTLINE PRESS·

AN OUTLINE PRESS BOOK

© STUART TROTTER 1990
First published in Great Britain in 1990 by
Outline Press (Book Publishers) Limited
115J Cleveland Street
London W1P 5PN

ISBN 1.871547.04.0

This book was designed and produced by
THE OUTLINE PRESS

Typesetting by Midford Typesetting Ltd.

Printed and bound by Grafoimpex, Zagreb, Yugoslavia.

·C·O·N·T·E·N·T·S·

INTRODUCTION

Drawing cartoons isn't always as easy as it looks, but there is a lot of fun to be had in creating your own cartoon world. The best advice is to try out all your ideas and just keep drawing – your own distinctive style will soon emerge through the work.

A great cartoon makes its impact immediately but can stay in your mind for years. Whether it's for pure entertainment or to put across a serious comment in an entertaining form, cartooning is one of the most economical and effective ways of communicating an idea. An appealing aspect of cartoons is that it can be as much fun for the artist to draw them as for the viewer to enjoy the joke, but beware of starting with the idea that because cartoons look simple, they must be easy to do. There is some distance to go between a visual gag that looks wonderful in your mind's eye and one that works equally well on paper. This book aims to help you achieve what you want from drawing cartoons, to give your ideas concrete form and your own special style. Lots of people start by copying the style of a cartoonist that they particularly admire – this can be as good a way as any to get yourself started and your own style and methods of drawing will gradually come through. The important thing is to be doing it rather than thinking about it. In trying out different ideas and having the courage to reject your first efforts and proceed beyond your initial aims, you may surprise yourself with how inventive you can become as a cartoonist.

Where to start

A cartoon gets little attention – however memorable the image may ultimately prove, its most important job is to get the point across quickly and accurately. To this end, whether you are drawing a single figure or a complex scene with many characters and props, you need to train your eye to pick up the essential details of your subject and your hand to sketch them confidently and unambiguously. Although the whole picture may come into your head on the basis of a verbal or visual idea,

you need to be able to draw the image in a way that conveys all the necessary information and makes all the elements reasonably consistent, in their relationships to each other and in terms of your style of drawing.

To make it easier to identify all the components of a cartoon, the book is broken down into chapters focusing on the important items you might want to include – human faces and figures, animal characters, inanimate objects and

backgrounds. It may help to get you started if you just copy the examples through the book, but each chapter explains some important general points – about positioning the features on a head turned at an angle, for example, or establishing the basic proportions of a figure – that will help you to analyse where you might be going wrong in your own drawings or, when something turns out just right, exactly why it is working so well. Everybody has an occasional inspiration that produces an immediately successful result, but you can't rely on happy accidents. You need to keep drawing, roughing out your ideas, sharpening the images and eliminating anything that doesn't make a useful contribution, so that you gain complete control of your cartooning skills and can produce a good result consistently.

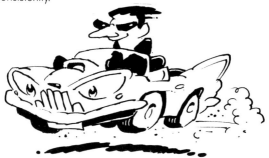

Gags and comic strips

Cartoons work very economically, and this applies to verbal as well as visual content. If you are drawing a spot gag with a caption or a strip feature with narrative and dialogue, the images carry much of the joke or story and the words need to be brief and straight to the point, underlining the humour or drama of the situation.

When you create a gag strip or comic strip in which the same characters reappear, you have to pay careful attention to making them recognizable in each frame in which they appear. This will be easier if you have already absorbed the basic elements of figure drawing, character development, perspective and background atmosphere that are explained in the chapters on individual subjects. The final chapter deals with putting all the elements together to tell a joke or a story, adding the words and not forgetting that a cartoon is the one purely visual artform in which you can include the extra dimension of sound.

MATERIALS AND METHODS

Just a few basic materials get you started on drawing cartoons. Pencil, pen or brush – you can work with whatever feels comfortable and gives you a good quality of line. Choose materials that let your ideas flow freely onto the page.

One of the main advantages in drawing cartoons is that your materials consist of relatively simple and inexpensive items and your method of work can be evolved to suit yourself. For black and white cartoons, you can start in the most basic way with a pencil and a piece of paper. Most cartoonists use pencil to make a number of roughs before working the final version in ink, but some advocate starting straight in with a brush or pen. As you develop your technique and style, you can find the working method best suited to your way of drawing and the purpose of your cartoons.

Pencils and crayons An HB pencil is ideal for roughing out drawings and refining to the finished trace (the stage before the finished drawing). Softer pencils are a bit too smudgy and harder pencils too light. One well-known cartoonist completes his drawings in pencil – for this you do need a softer, more grainy pencil such as a 4B or 5B. You can also use charcoal or conté crayon to give a grainy effect to the drawing. These materials give quite a heavy black that reproduces well and the line has a warmth that ink line does not. However, you do need to take extra care to keep the work clean, as all these materials smudge easily.

Pens and brushes For inking the final version of the cartoon, you can use a pen or brush and black ink. There are all sorts of pens that give a wide range of line. The traditional dip pen or mapping pen is very versatile, giving a scratchy, active line that can vary from thin to thick. With dip pens you don't have total control of the ink flow, so you need to beware of blotching. Technical pens with tubular nibs fed by ink cartridges are very useful for fine detail such as cross hatching, but the advantage of

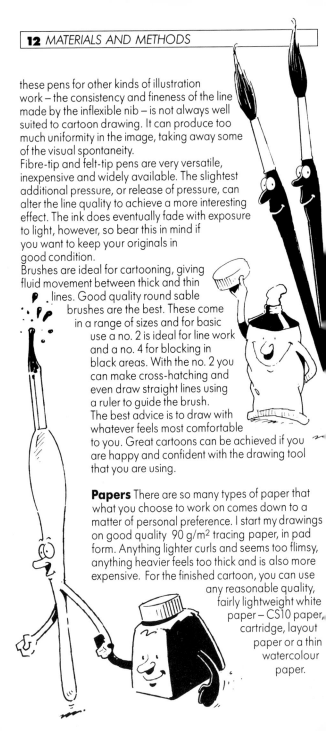

these pens for other kinds of illustration work – the consistency and fineness of the line made by the inflexible nib – is not always well suited to cartoon drawing. It can produce too much uniformity in the image, taking away some of the visual spontaneity.

Fibre-tip and felt-tip pens are very versatile, inexpensive and widely available. The slightest additional pressure, or release of pressure, can alter the line quality to achieve a more interesting effect. The ink does eventually fade with exposure to light, however, so bear this in mind if you want to keep your originals in good condition.

Brushes are ideal for cartooning, giving fluid movement between thick and thin lines. Good quality round sable brushes are the best. These come in a range of sizes and for basic use a no. 2 is ideal for line work and a no. 4 for blocking in black areas. With the no. 2 you can make cross-hatching and even draw straight lines using a ruler to guide the brush. The best advice is to draw with whatever feels most comfortable to you. Great cartoons can be achieved if you are happy and confident with the drawing tool that you are using.

Papers There are so many types of paper that what you choose to work on comes down to a matter of personal preference. I start my drawings on good quality 90 g/m² tracing paper, in pad form. Anything lighter curls and seems too flimsy, anything heavier feels too thick and is also more expensive. For the finished cartoon, you can use any reasonable quality, fairly lightweight white paper – CS10 paper, cartridge, layout paper or a thin watercolour paper.

Other equipment

Although you are ready to begin work with no more than a pencil, paper and pen, there are a few other items that make life easier. To sharpen your pencils, use a scalpel with a fine, sharp blade. You can buy the scalpel handle together with packs of disposable blades in most art supply stores. The most versatile blade is the 10A, which has a straight cutting edge angled to a fine point. With this you can not only sharpen pencils but also scratch out errors in your drawing and trim paper or card. The blades are very sharp and should be used with great respect. Replace the blade as soon as it seems to have lost its edge.

Additional drawing aids include an eraser, ruler and set square. For making minor corrections to an inked drawing you can simply paint out the error with opaque white. Keep a clean no. 2 sable brush for the white, separate from the one you use for black ink. More general materials that you will find useful include masking tape, blotting paper and kitchen towels.

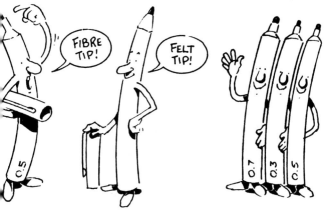

Working method If you have worked out the drawing in rough form on tracing or layout paper, you need to transfer this to the surface you have chosen for the finished drawing before you begin to ink it in. Some artists feel that refining the drawing in rough form takes away the spontaneity of the finished version, but there is nothing wrong with getting your drawing right in the pencil version, rubbing out and reworking the details until you feel the image is both well drawn and expressive of your idea.
To transfer the drawing from your rough to the final paper, you can use the conventional methods of tracing or using a transfer paper. The easiest and quickest way, however, is to use a light box.
Simply place the original rough on the light box, tape your clean paper over it and work directly in ink, following the guidelines showing through from the original. This still leaves room for spontaneity but eliminates much of the labour, and the potential for error, that is involved in going over the drawing two or three times with the ordinary tracing method.

Colour work
This book is strictly concerned with black and white cartoon drawing, but if you wish to add colour you can use any of the readily available media – markers, watercolours, gouache or drawing inks. Full-colour work for reproduction is usually scanned mechanically to break it down into process colours for printing. For scanning, the artwork must be flexible, so it is easiest to work on paper. If you prefer the rigidity of board, you can

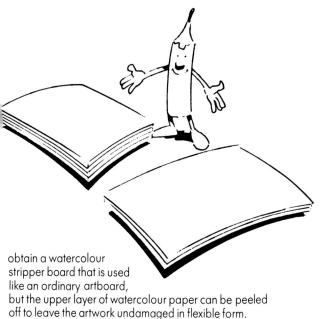

obtain a watercolour
stripper board that is used
like an ordinary artboard,
but the upper layer of watercolour paper can be peeled
off to leave the artwork undamaged in flexible form.

Protecting your cartoons

While you are drawing, to avoid smudging the artwork or
putting greasy fingermarks on the paper, lay a loose sheet of
paper over the drawing on which you can rest your hand.
For protection and presentation of the finished artwork, cover it
with a sheet of layout paper and over that a sheet of coloured
paper, both taped to the top edge of the artwork on the wrong
side and folded down
over the drawing. You
can adopt a particular
colour for the
covering sheet that
makes your artwork
easily recognizable.
For a different style of
presentation that gives the
cartoon immediate impact,
place a sheet of acetate
over the drawing and make
a window mount of cartridge
paper to border the image.

FACES

The face is often the key to your cartoon character, conveying a lot of information about personality and mood. This chapter explains the components of an expressive face and how to put them together.

A sense of character can be created out of many details of the human figure – not only the face but the pose of the body, the mannerisms, the clothing and hair. But, as in life, in a cartoon the face is a particularly important means of expression and a good starting point for your drawing.

A few dots and lines can add up to a surprisingly expressive cartoon face, but the more detail you choose to include, the more the features contribute to the particular impression that you wish to convey. Remember, though, that drawing cartoons is an economical process and you are looking for essential elements that do the job quickly and effectively. Cartoon conventions can be useful – wide open eyes with floating pupils showing surprise, for example, or an unmistakably angry row of bared teeth. You can get ideas for your drawings both by studying how other cartoonists represent features and expressions and through everyday observations of the people around you.

It is quite easy to draw a straightforward frontal or profile view of the face, but more difficult to work out how to put the features together if you are showing the head turned at an angle – to right or left, up or down. To begin with, this section shows a simple way of using ellipses to plot the position of the features from all angles. This gives you a basic construction to which you can apply the descriptive details of your cartoon character.

Caricature The art of caricature differs from that of cartooning in that you are aiming to produce a recognizable portrait rather than a character type. However, as with cartoons, the features are simplified and the most characteristic elements are somewhat exaggerated. The simplest way to begin a caricature is to study a photograph of your subject, whether someone you know or a celebrity, and to pick out essential details as the basis of your drawing. Examples of caricature are shown on pages 26 and 27.

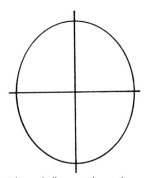

A broad ellipse with axis lines gives basic proportions

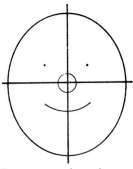

Eyes, nose and mouth are centred on the axis lines

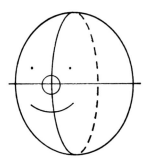

A three-quarter view sits on an ellipse plane on the vertical axis

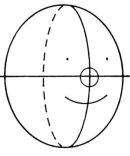

The same principle applies to left side or right side views

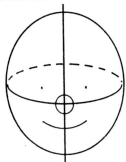

Looking down, use the ellipse plane on the horizontal axis

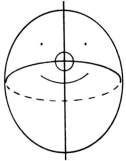

Looking up, use the reverse of the same horizontal ellipse

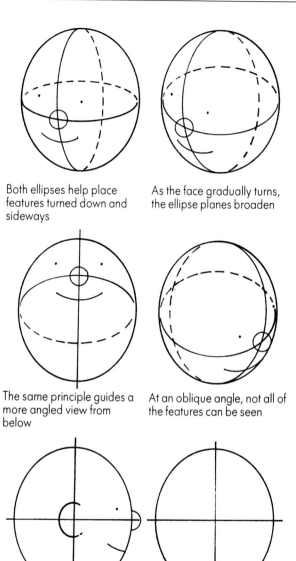

Both ellipses help place features turned down and sideways

As the face gradually turns, the ellipse planes broaden

The same principle guides a more angled view from below

At an oblique angle, not all of the features can be seen

A profile view is also plotted using the main axes

From directly above the head, only the nose is visible

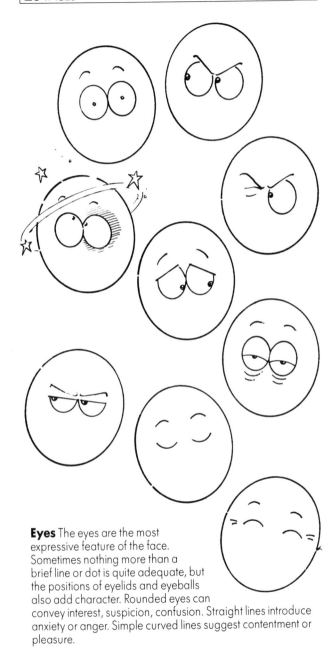

Eyes The eyes are the most expressive feature of the face. Sometimes nothing more than a brief line or dot is quite adequate, but the positions of eyelids and eyeballs also add character. Rounded eyes can convey interest, suspicion, confusion. Straight lines introduce anxiety or anger. Simple curved lines suggest contentment or pleasure.

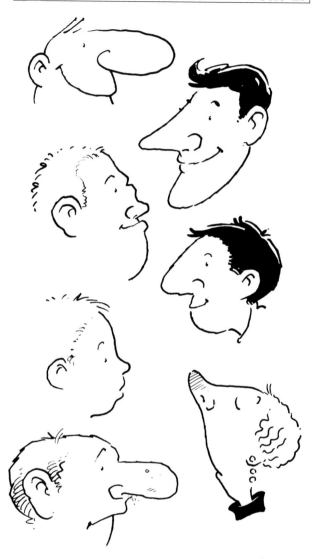

Noses The nose is a useful device for categorizing the cartoon character. For example, a belligerent fellow can be given a broken nose, a sharp character is shown with a pointed nose, a snobbish person with a nose stuck up in the air. Adult characters can be given quite exaggerated noses, but children's noses are typically small and simply shaped.

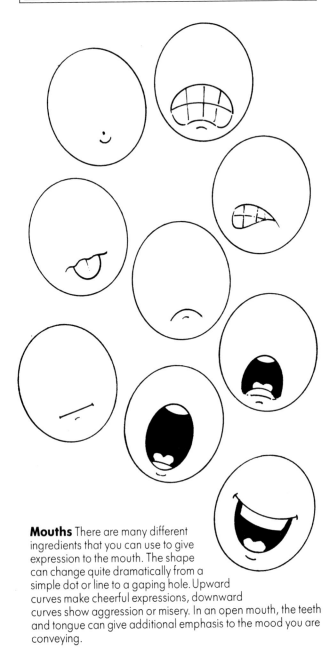

Mouths There are many different ingredients that you can use to give expression to the mouth. The shape can change quite dramatically from a simple dot or line to a gaping hole. Upward curves make cheerful expressions, downward curves show aggression or misery. In an open mouth, the teeth and tongue can give additional emphasis to the mood you are conveying.

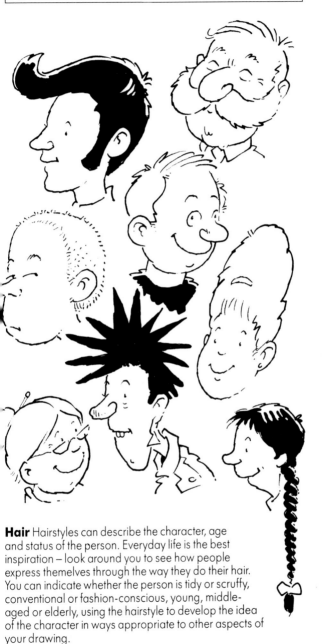

Hair Hairstyles can describe the character, age and status of the person. Everyday life is the best inspiration – look around you to see how people express themelves through the way they do their hair. You can indicate whether the person is tidy or scruffy, conventional or fashion-conscious, young, middle-aged or elderly, using the hairstyle to develop the idea of the character in ways appropriate to other aspects of your drawing.

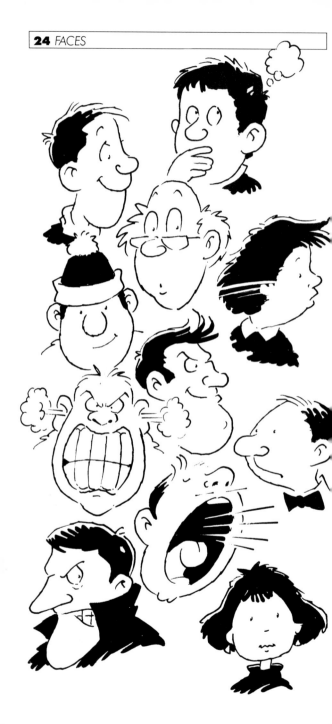

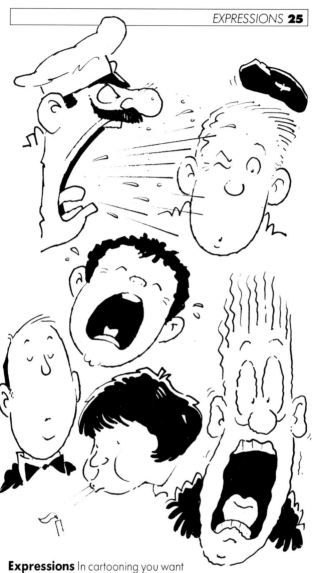

Expressions In cartooning you want
to convey your idea as directly as possible,
with all the features of the face giving emphasis to mood and
character. For example, how do you tell if a wide open mouth is
shouting, singing, wailing, or showing terror? The other features
should make the context clear. The quality of line also adds
expression – firm lines may be serene or aggressive, broken or
wavy lines are confused, anxious or terrified.

Caricature The art of caricature is to bring out the essential details that identify a person. You can start with a photograph of someone you know and simply pick out the obvious features, then exaggerate them gently.

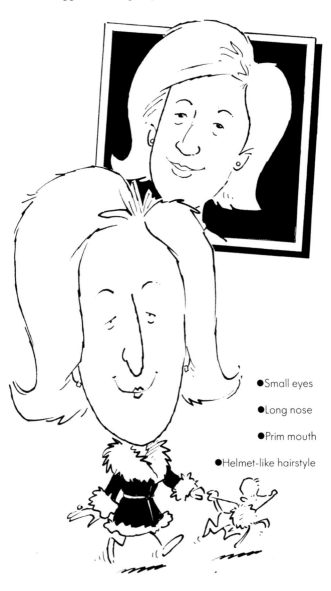

- Small eyes

- Long nose

- Prim mouth

- Helmet-like hairstyle

Once you have a sense of the caricature in the details of the face, you can add clothing and accessories that create a commentary on the person's lifestyle and interests. Usually, the proportions in a caricature figure are also exaggerated.

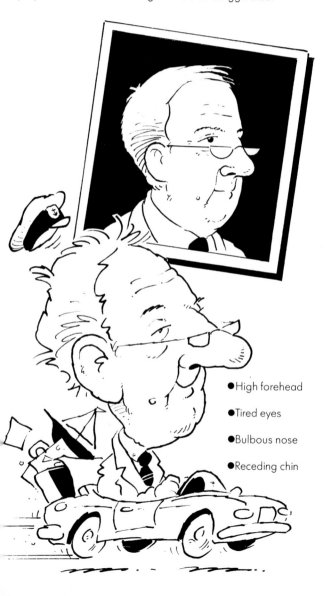

- High forehead
- Tired eyes
- Bulbous nose
- Receding chin

chapter three

FIGURES

The appearance and
actions of a cartoon figure
are often exaggerated for
comic effect. Beginning
with basic proportions,
you can see how to give
character and movement
to the figure by
developing the detail and
using a few visual tricks.

There is no one easy or correct way to develop a cartoon character. You might start with the face and build up a portrait of the person, then gradually work through the details of the body; or you might have an overall idea of the physical person – short and fat, tall and thin – or a sense of who or what they are – a sportsman, a glamour girl, a naughty schoolkid. As with faces, the people you see around you give you plenty of information that can be adapted to cartoon drawings, from basic poses and actions to the many telling details of clothing and outward style that make up a personality.

This chapter breaks down the figure into its different component parts to give you various clues as to how to develop a convincing cartoon figure. Although cartoons need a lot of imagination, there is a lot to be gained from understanding simple basic elements of figure drawing, such as overall proportions and the articulation of particular types of movement. This helps you to create the kind of character you are looking for, and you can then elaborate it with the extra details that make it very specifically your own creation.

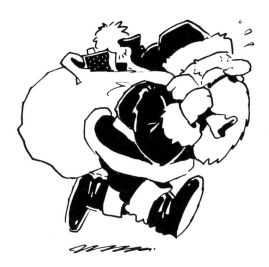

When you come to put the character into a context, there are various devices you can use to add impact to the action or tell a simple story within a single image. Finally, though, the visual and comic inspiration for a good cartoon must be your own, so make lots of rough drawings and follow up all your ideas about how to make your characters come alive.

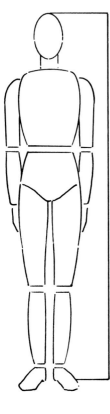

Proportions When you are drawing cartoon figures there is room for some distortion and exaggeration for comic effect, but whatever kind of character you are creating, it has a more convincing appearance if the basic proportions are correct. This mannikin shows how to break down the figure into simple components that have consistent relationships to each other. The body has two basic sections, each of the limbs has three. The elbow joints are at waist level, the distance between elbow and wrist is a little shorter than the length of the upper arm. The legs are similarly divided between hip, knee and ankle. If you have a clear idea of these simple proportions and the positions of the joints, you can more easily imagine the figure performing a particular action.

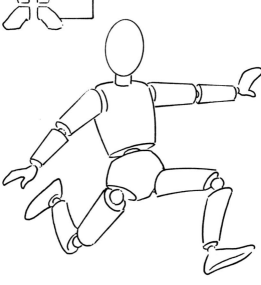

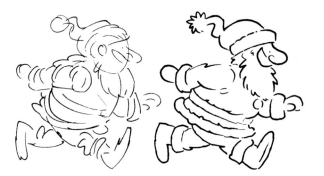

Small and tall Although these two characters look very different each corresponds to the basic scheme of proportion described opposite. The consistent relationships between the various part of the body are the same whether they are applied to a small or tall, fat or thin character. It is simply a matter of adjusting the overall shape while maintaining the key points, such as the arms bending at waist level.

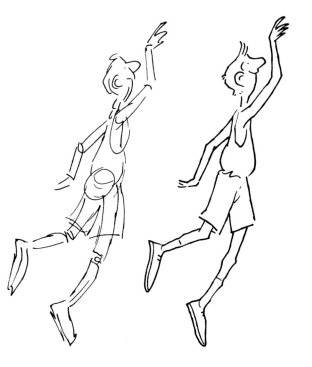

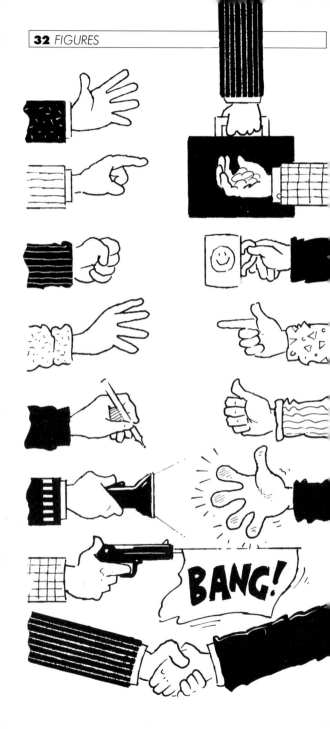

BANG!

Hands and arms Hands are a very expressive part of the
figure and can be drawn as very simple shapes or with a more
detailed sense of form. You may find that in some circumstances
the whole hand looks rather clumsy – many cartoon hands work
very successfully using only three fingers and a thumb. The
shape of the arm can also be greatly simplified in character with
the rest of the figure, or you can give exaggerated attention to
the wrist and elbow joints for comic effect.

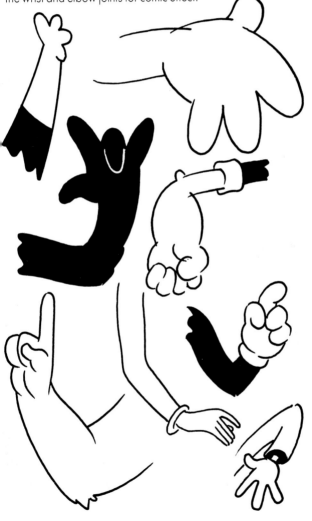

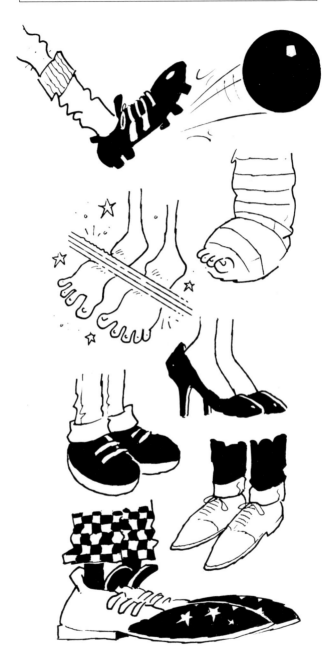

Feet and legs These elements of the figure give you a lot of scope to develop the idea of who the character is and what he or she is doing. Shoes can give a very detailed and humorous indication of personality or character type. Legs, too, help to build the character profile as well as articulating specific actions and movements.

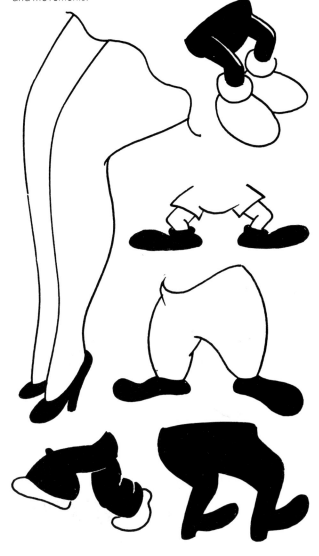

Children It can be difficult to draw a character that looks distinctly childlike, rather than one that resembles a scaled-down adult, but there are a few essential details that help to identify a cartoon child. The general proportions of the body can work in the same way as those described on page 30, which creates the necessary consistency that you can apply to movements and actions, but usually the head is larger in relation to the rest of the body. A high forehead and simple features like a small button nose are also characteristic of children.

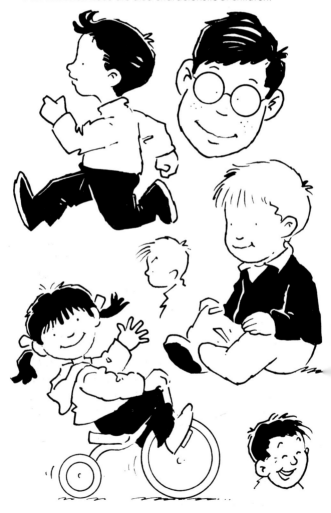

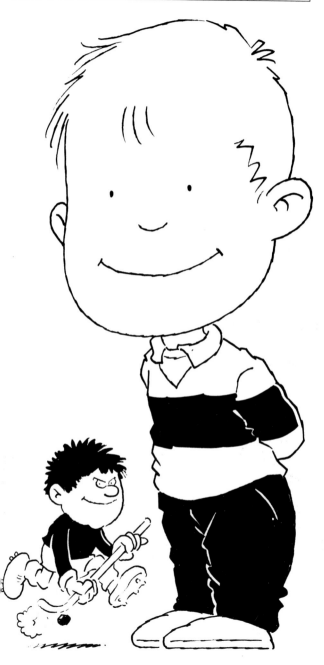

Walking The sequences on these pages show the figure performing the basic actions of walking, running, jumping and falling. Although this walking figure is striding out quite purposefully, the upright torso and relaxed arm movements indicate that he is walking and not running.

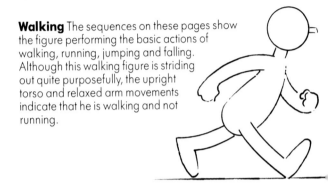

Running As the figure speeds up he leans forward into the run and his arms rise higher behind him and bend more sharply at the elbow. The leg swinging back between strides is also more forcefully bent.

Jumping Movement in cartoon figures is usually exaggerated and this sequence shows how the action of jumping is graphically emphasized with the body crouched ready to spring, then hurling itself forward into the air, then landing with the feet coming through ahead of the body. The position of the arms underlines the balance of the body at each stage.

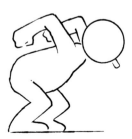

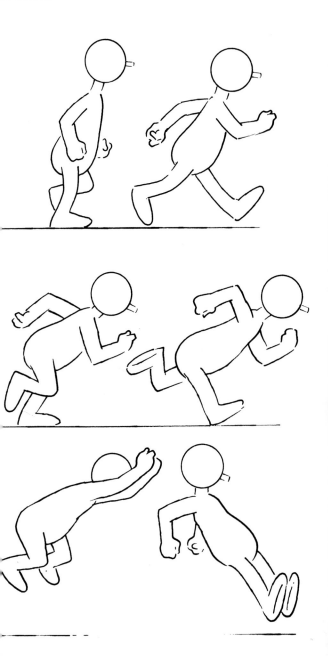

Walking – front view Whereas from a side view the action is clear from the angle of the torso and positions of the limbs, the front view has a less dynamic outline so you need to make the movement as explicit as possible. The walking man again has a relaxed posture but in this view the angle of the torso remains relatively consistent throughout the sequence. It is the action of his arms, legs and feet that explain the kind of movement he is making.

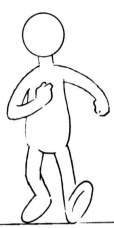

Running – front view In this sequence the body leaning forward into the run becomes slightly foreshortened and the arm and leg movements become more active and exaggerated to explain the forward momentum directed towards the viewer. The knees and arms bend more aggressively, the feet barely touch the ground. The overall shape of the body is more compact, with the neck almost disappearing, but the limbs are more angular.

Falling This is what happens when you don't look where you are going. This sequence is typical of the exaggerated movement of a cartoon, with the legs and arms flying out from the body as the figure slips, then thrown upward as he lands on his back.

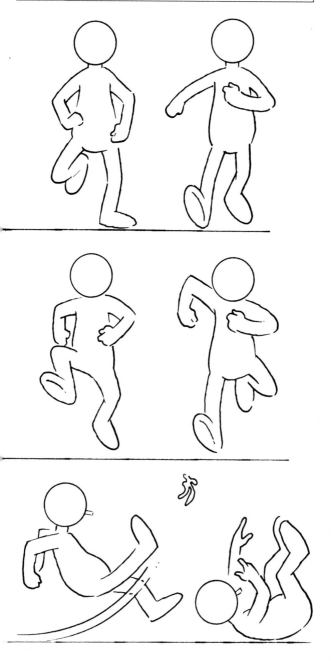

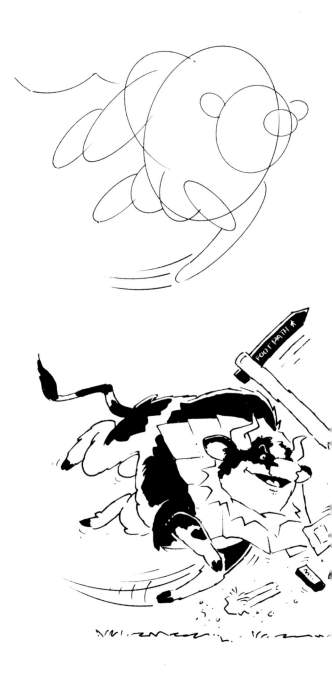

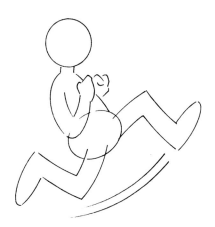

A diagrammatic breakdown of this cartoon shows how the forward momentum of the bull is emphasized by its wide shoulders and narrow waist. The running man leans backwards because weighed down by his rucksack. The finished cartoon is full of eventful detail such as the bull's head bursting through the map and the panicked hiker's belongings scattering behind him.

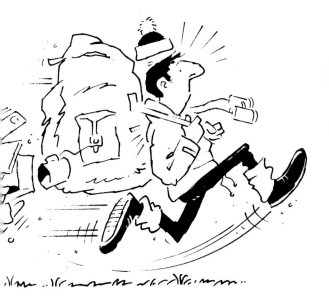

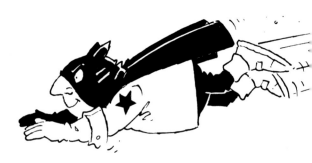

Movement lines The cartoon figure spells out the basic action but, as in these examples, illustrative conventions such as movement lines give a more emphatic sense of the figure's activity. Above, curving lines receding behind the flying superhero indicate his speed and direction. The puffs of smoke encircling his trail exaggerate the effect of movement. In the cartoon below, the lot of the unhappy postman fleeing from a snappy dog is

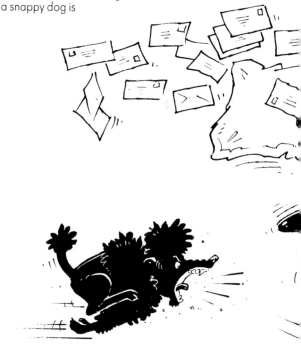

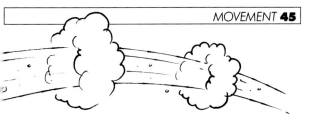

given humorous detail with a number of visual devices. White lines on solid black describe his rumped clothing. The nervous lines fanning out from head, hands, legs and feet indicate his anxiety and the movement lines trailing from his front leg emphasize his speed. The more abrupt, concentrated details applied to the compact shape of the barking dog give it a distinctly aggressive mood.

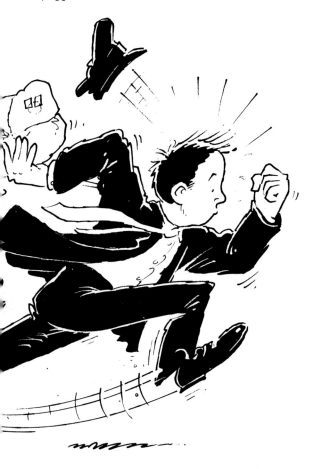

Visual impact These cartoons show various simple devices
that give additional strength and humour to the action
depicted. The impact of a blow, from a fist, mallet or
custard pie, is more painfully comic when it is
exaggerated, as with the spring-propelled boxing glove burying
itself in the victim's face. Large gestures such as
throwing and hitting should be fluidly described,
with very direct connections made between the different
elements in the cartoon.

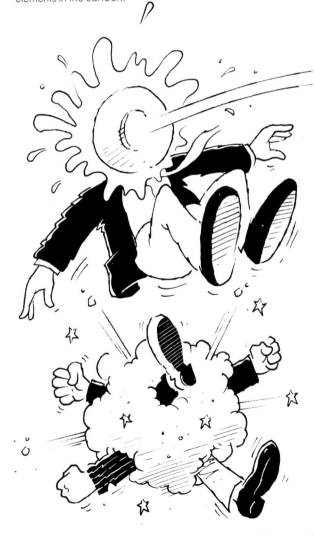

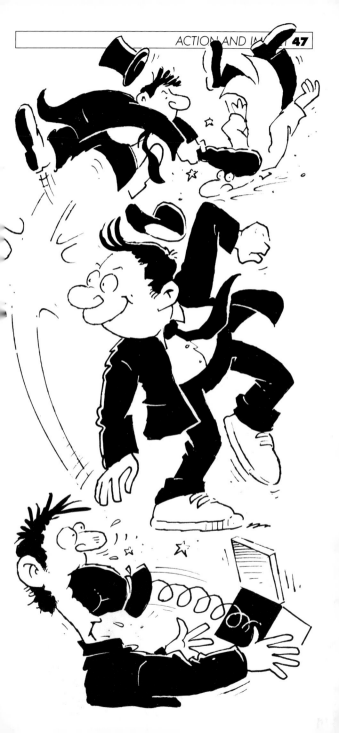

ANIMALS

The variety of animal
types is a great resource
for cartoon imagery.
Animals have provided
some of the most enduring
cartoon heroes, but also
give the cartoonist lots of
scope for incidental detail
and humour.

Animals make great subjects for the cartoonist, lending themselves to a variety of humorous interpretations and providing many different elements of shape, texture and movement that can add visual interest to your drawings. In a cartoon you are not confined by any realistic approach to what an animal can be or do. You can use animals as a foil for the human characters in a cartoon, or give them characteristics of their own that are more human than animal. You can give them a straightforward role as household pets or inhabitants of a zoo, or create "stories" in which they can be heroes or villains, tricksters or fall-guys.

As with all aspects of cartoon drawing, the image should make the point quickly and unambiguously, so it needs to be absolutely clear what the animal is and what it is doing. You need to study the natural model to work out its characteristic shape and features – it's useful to build up a file of photographs from newspapers and magazines that can provide reference for different types of animals in a variety of situations. When you can draw to your satisfaction the basic elements that identify the animal, you can play around with its movement and expression to get across the point of the cartoon representation.

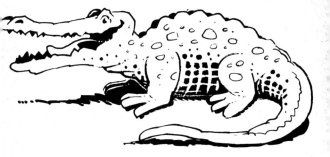

Certain kinds of animals have particular characteristics attributed to them – sheep are often thought to be stupid, for example, cats devious, foxes cunning, cows placid. You can make use of these associations or get an unexpected element of humour out of reversing the viewer's expectations. You can also think about choosing the right kind of physical appearance to suggest character – fat or thin, rounded or angular, plain-coloured, patched or spotted. Don't overlook any element that can enhance the effectiveness of your cartoon, in terms of both its visual impact and its ability to make the joke or tell the story.

Animal characters
As with people, the expressions and poses of your cartoon animals convey some of the background to the story. You can get a lot of fun out of the interaction between animals, as with this perky cat that appears to be quite unworried by facing up to a large, angry dog.

Typically, animals are "humanized", as with a four-legged animal standing upright, its paws becoming hands and feet. The cat's face is also adaptable to a variety of moods.

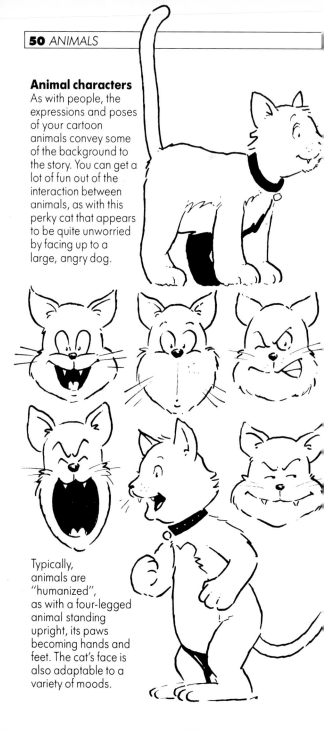

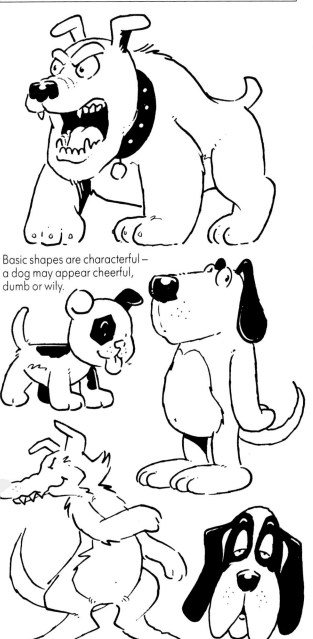

Basic shapes are characterful –
a dog may appear cheerful,
dumb or wily.

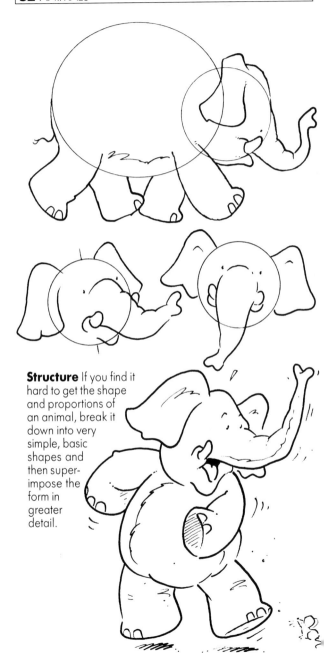

Structure If you find it hard to get the shape and proportions of an animal, break it down into very simple, basic shapes and then super-impose the form in greater detail.

Movement A clear idea of the component parts of the animal and how these fit together makes it easier to visualize it in different ways. Slightly ragged or broken lines add to the sense of movement.

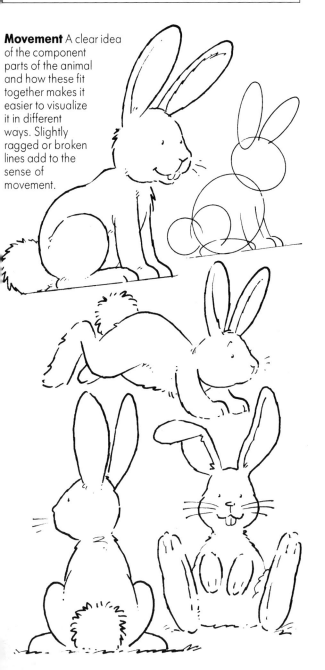

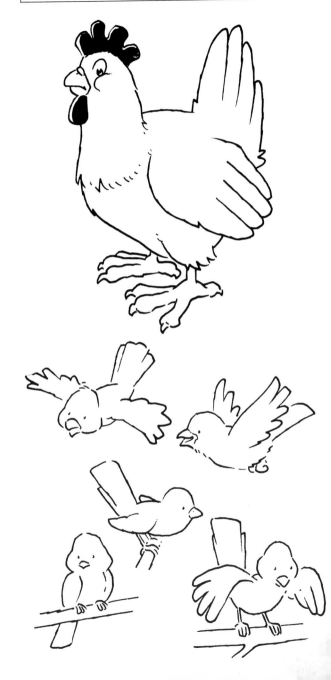

Birds The overall body shape and specific details such as beak, claws and tail feathers quickly identify each different type of bird.

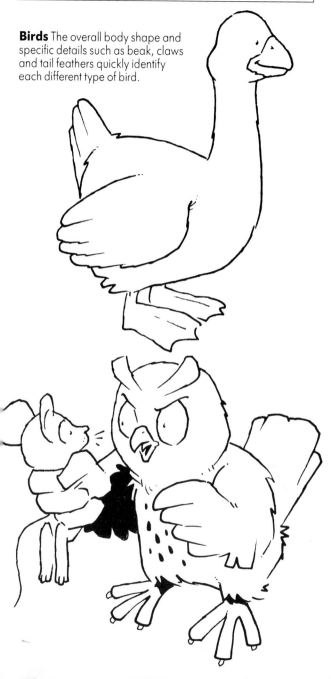

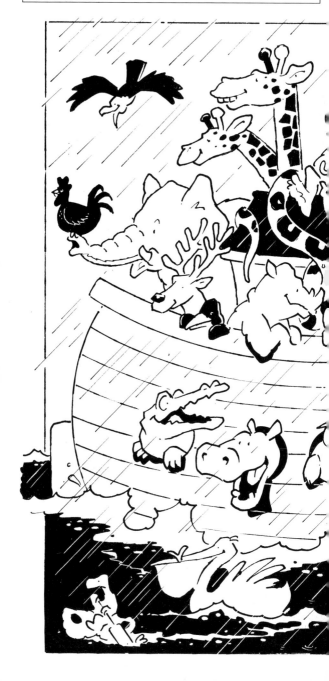

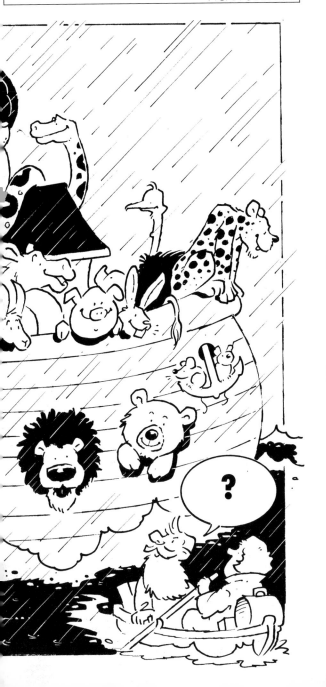

INANIMATE OBJECTS

Any kind of object can lend itself to cartoon interpretation. With a little thought, you can soon see the most effective way to give character and animation to man-made or natural forms.

Any object can be turned into a cartoon character. Some readily present their potential to be "humanized" in that they come equipped with components easily turned into facial features or limbs, while with others you may need to experiment more freely with the shape and form before you find the best way to give a definite personality to the item. In the following pages there is a wide range of examples – simple objects such as a glove, playing card or dish and spoon, and mechanical or electrical products with more complex detail that you can adapt to a specific character.

Vehicles often suggest character by their shape and function – features such as windows, lamps, funnels, wings and tyres are excellent resources for giving personality and animation to the shape of a car, aeroplane, boat or train. The front of a car almost automatically translates itself into a face and the configuration of the different components will often suggest the type of character – a small car can become a dumpy character with a friendly face, while an angular, streamlined vehicle can be given a positively menacing personality.

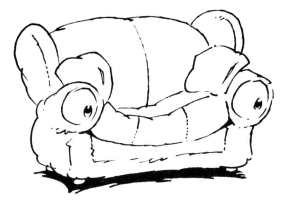

Some very successful cartoon heroes and villains have been created out of inanimate objects, who have unexpected adventures sometimes taking them right out of their normal context. They can also be accessories to a story in which human or animal characters have the main roles, or they can simply add a little background humour not entirely related to the central point of the cartoon but providing some extra visual interest. Cartoon representations are often very successfully used in advertising and product promotions to give a human angle to the item on display.

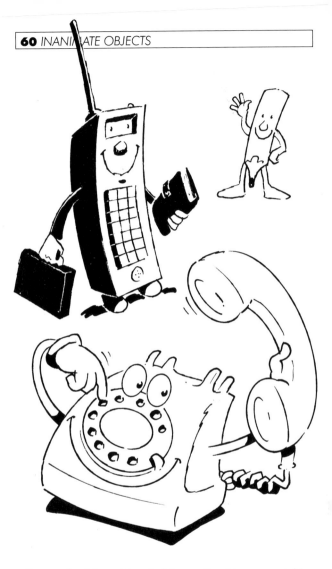

Domestic objects Not all of the smaller objects you might want to use in a cartoon drawing have readily recognizable "faces", but you can usually find a suitable place to put eyes and a mouth, for example. It is not necessary to incorporate all the features, although something like a spout of a teapot or watering can gives you a readymade "nose" for your character. It is also easy to activate the basic shape of the object and graft on simple limbs, sometimes with related accessories that emphasize the point of the cartoon.

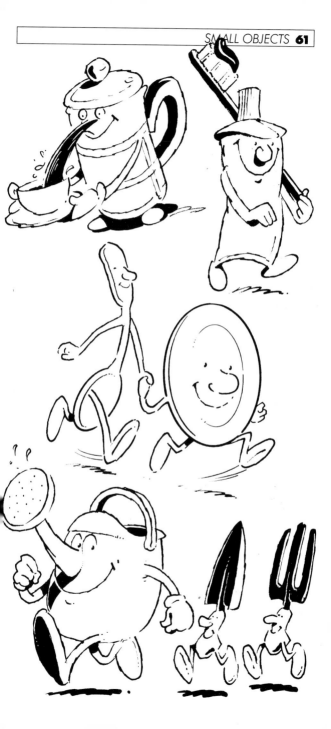

Vehicles The front of a car forms a natural face, with the headlamps making its eyes and the grille adapting easily to a smiling or angry mouth. The urge to give personalities to cars, trains and planes is almost irresistible, once you look at the basic components and see how easily they transpose into

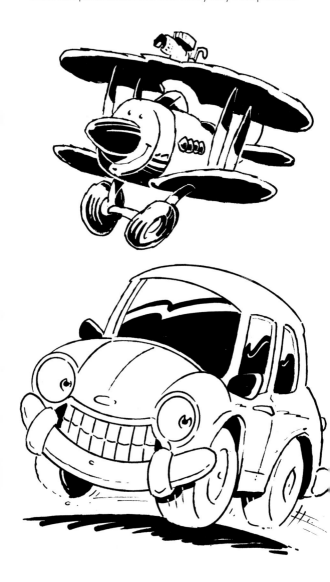

expressive features. Simplifying the overall shape of the object also adds to the cartoon impression; as in the examples shown here, the rounded forms of the two different aeroplanes contribute to a cheerful, carefree mood appropriate to flying.

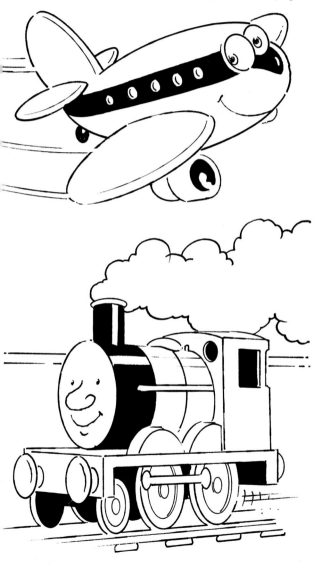

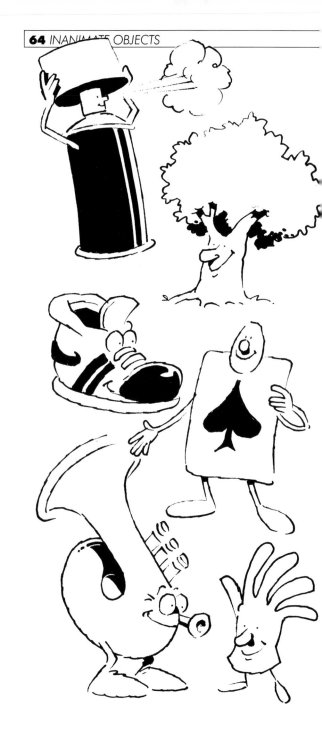

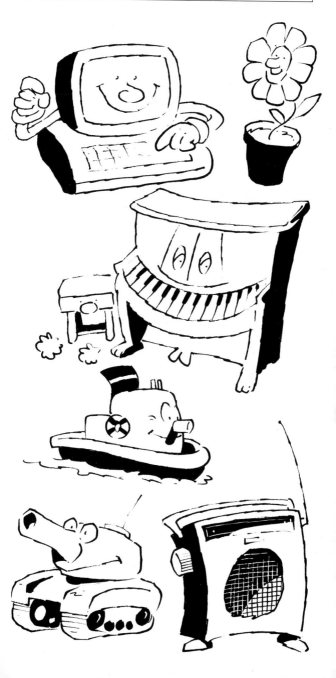

BACKGROUNDS

With a basic grasp of perspective and imaginative attention to detail, you can create a setting for your characters that helps to tell the joke or story and gives additional visual interest to your drawing.

The setting for a cartoon, if you choose to include scenery or background detail, can be as simple or as complex as you like. If you wanted to show a man lost in a desert, just a few lines describing the far horizon and the impression of heat would immediately explain his predicament, whereas to show a super hero flying to the rescue you might need to construct a complex aerial view of tall buildings. The background obviously relates directly to the context of the cartoon – a vampire joke might take place in a sinister churchyard, a couple arguing may be seen in a domestic interior.

A basic knowledge of perspective helps you to locate a character within a descriptive context. One-point and two-point perspectives create effective three-dimensional impressions of interiors, roads or railways running into the distance, street scenes or other architectural structures. Three-point perspective gives additional drama – a bird's eye view of tall skyscrapers or a worm's eye view that makes a building seem enormously tall and dominant. Examples of different perspectives are shown in the following pages and it's worth investigating the subject a bit further if you want to create detailed cartoon backgrounds. There are many different elements to consider in setting up your scene – not only the scale and perspective of basic structures but also the appropriate details that you should include and the way you can use line and tone to enhance the mood or atmosphere of the drawing. The final drawings in this section (pages 72 and 73) show how the same building can be presented in very different ways by altering the perspective and setting. You can apply this principle to all sorts of situations that might provide the surroundings for your cartoon characters.

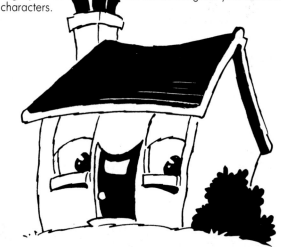

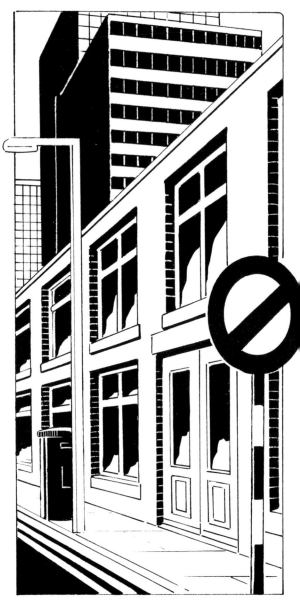

This street scene is based on a simple one-point perspective as shown opposite.

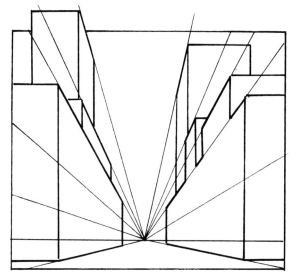

One-point perspective Horizontal lines converge on a single vanishing point on the horizon line.

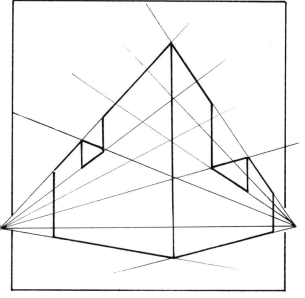

Two-point perspective Two vanishing points give a more versatile approach to the angle of view.

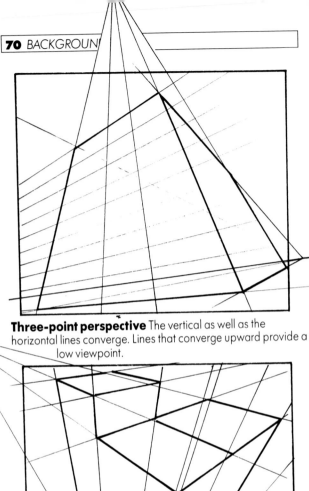

Three-point perspective The vertical as well as the horizontal lines converge. Lines that converge upward provide a low viewpoint.

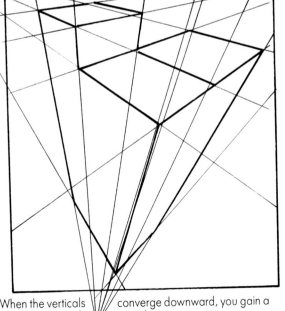

When the verticals converge downward, you gain a bird's eye view of your subject.

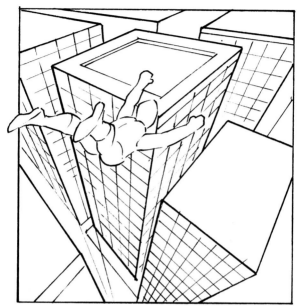

The basic construction of the bird's eye-view simply translates into tall skyscrapers.

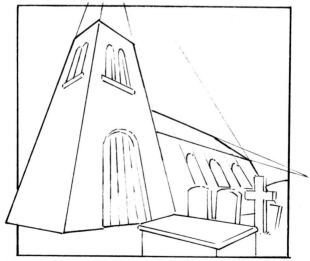

A low viewpoint gives an exaggerated effect of height, making a building very dominant.

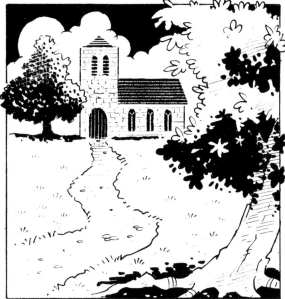

A straightforward frontal view tends to be more pleasant and inviting. This impression is enhanced by leafy trees and a pathway leading into the scene.

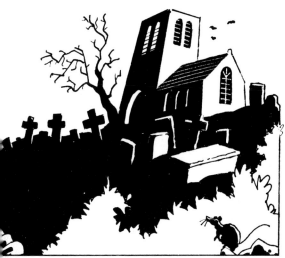

A sinister atmosphere is created by placing the church in a deep perspective, with enlarged foreground detail and heavy blacks casting the shapes into silhouette.

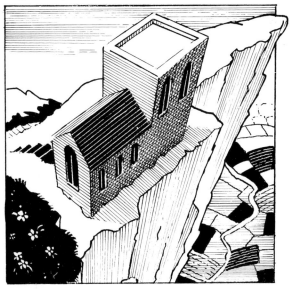

The bird's eye view previously applied to the cityscape creates an equally dramatic natural setting – a high cliff, with distant landscape spread out below.

PUTTING IT ALL TOGETHER

Whether your cartoon is a one-off gag or a continuing adventure story, this chapter explains how to present the images effectively and how you can complement them with a few well-chosen words — as captions, dialogue or sounds.

If you have followed through all the elements of the previous chapters, you now have a good grasp of your cartoon characters and situations. This chapter deals with the different ways you can present a cartoon as an individual joke or in story form.

We start with the spot gag, a single image with or without a caption – the kind of cartoon that you find filling spaces in newspapers and magazines. You can think these up to suit characters that you have already worked out, or you might get an idea for a one-off gag and invent the characters and situation to go with it. The idea here is to make immediate impact, as spot gags only get fleeting attention and no one wants to have to work hard at finding the joke.

The other main form is the cartoon strip. This can be a self-contained gag strip that tells a joke in three or four frames, or a story strip that continues daily or weekly in a newspaper over a long period of time, with plenty of cliff-hanger endings to the individual sequences that bring the readers back for more. The comic book can incorporate a variety of forms – individual stories in words and pictures that may be humorous or exciting, sometimes a combination of the two, or gag strips in a variety of styles.

Cartoon strips introduce the opportunity to use narrative and dialogue, which means you need to acquire the skill of writing into a balloon or a portion of the frame. Remember, though, that the point of this form of story-telling is that it is visual. The words help to move the story along and add detail and atmosphere, but the pictures are the story, not just illustrations to the text. On pages 78 to 83, you'll find comic strips that explain exactly how the visual devices work.

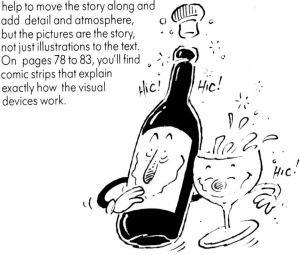

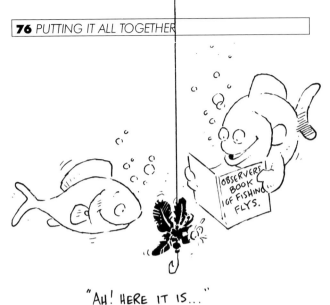

"AH! HERE IT IS..."

Spot gags The basic idea for a spot gag may come to you verbally, as a caption that begs for a humorous visual interpretation, or as a picture of a strange or funny situation that forms in your mind's eye. The image must grab the viewer's attention and make the joke immediately. If you do include a caption, and you don't have to, it should be brief and to the point, complementing the visual humour. As with the fish cartoon shown here, sometimes writing within the drawing is essential to the point of the gag. Often these cartoons don't have a frame and you don't need to include a background, but you can put in

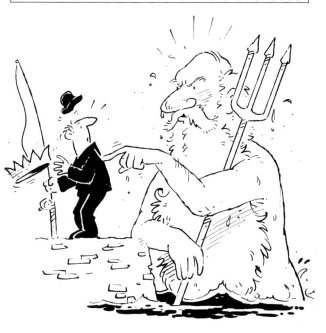

details that add to the effect, such as the bubbles around the fishes that give the impression of their watery surroundings. In the Neptune cartoon there is just enough detail of the sea and jetty to explain the context unambiguously, whereas the two cartoons below don't need a location, as the point of the joke is completely explained by the figures and objects and it doesn't really matter where they are.

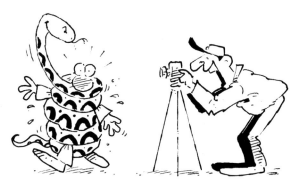

"I THINK HE LIKES YOU."

THE COMIC STRIP IS A WAY OF TELLING A STORY WITH WORDS AND PICTURES.

THERE ARE THREE BAS... FORMS..... GAG STRIP STORY STR... AND THE C...

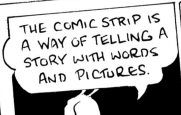

THE STORY STRIP!

THIS USUALLY APPEARS IN NEWSPAPERS TELLING A STORY OVER A LONG PERIOD, OFTEN YEARS. JUST LIKE THE GAG STRIP IT APPEARS IN THE SAME FORMAT, BUT EACH DAY ENDS ON A NOTE OF ANTICIPATION SO YOU WIL... COME BACK FOR MORE.

HOW TO...

... DRAW AND WRITE BALLOONS. WITH A SOFT PENCIL (HB) DRAW SOME GUIDELINES USING A RULER.

THE DISTANCE BETWEEN LIN... OF WORDS SHOULD BE L... THAN THE W... HEIGHT....

THE GAG STRIP!

THIS HAS TWO OR THREE PANELS IN WHICH TO TELL A HUMOROUS STORY. HA! HA! HA! HAAAA.

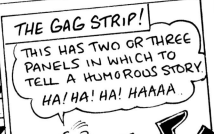

THE COMIC BOOK!

USUALLY IN MAGAZINE FORM IT CAN CONTAIN ONE STORY OR SEVERAL STRIPS WITH DIFFERENT STYLES AND CONTENTS.

WHEN THE WORDS ARE WRITTEN, DRAW THE BALLOON AT A SIZE THAT HOLDS THE WORDS COMFORTABLY!

ERASE THE PENCIL GUIDELINES.

WHEN FINISHED IT WILL LOOK LIKE THIS!

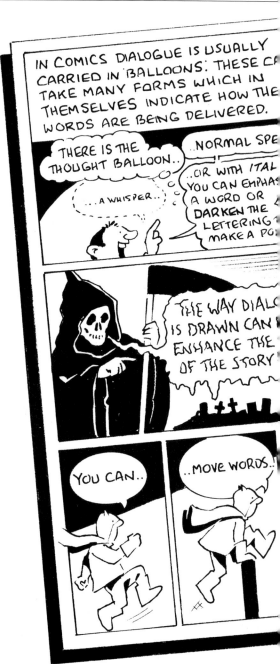

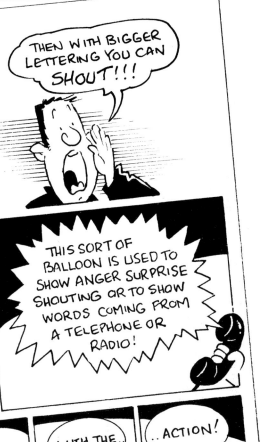

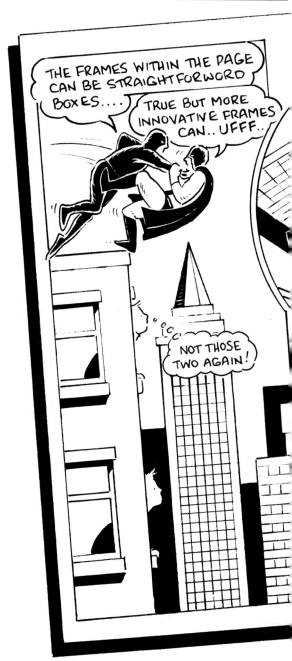

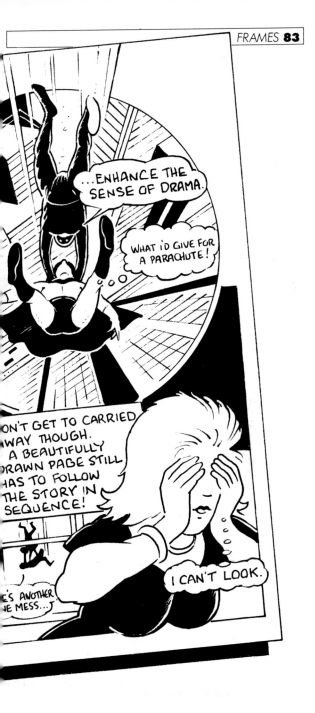

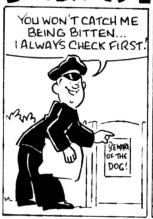

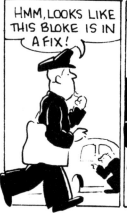

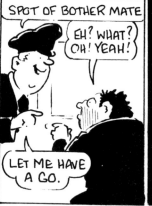

Gag strips Each series of frames in a gag strip tells a self-contained story, but the main characters reappear in different situations and both the visual characterization and the storylines

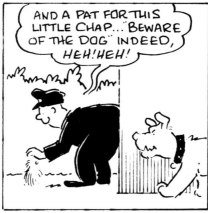

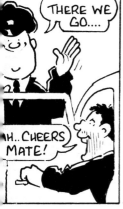

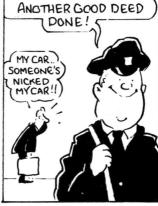

should present them consistently. Smart Alec is a cheerful chap whose well-meaning interferences inevitably lead to disaster.

Comic sounds A dustbin lid falling from a great height and hitting the ground may be drawn beautifully, but it conveys much more when you add the CLANG!! of its impact. Sound effects bring another dimension to your cartoons and can be applied to human or animal characters, inanimate objects and even elements of the background. Give visual emphasis to the kind of noise so that, for example, a loud noise looks loud.

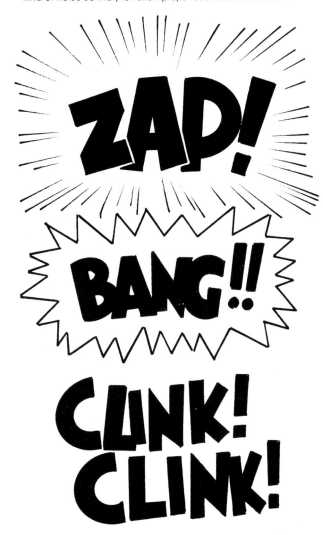

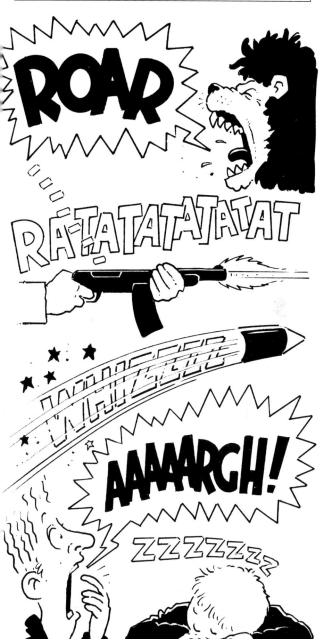

Cartoon sounds add to the activity of the drawing, both visually and in terms of the action. If you imagine this drawing without the sound effects, you can see that it becomes less eventful, although the characters and situation are described in plenty of detail.

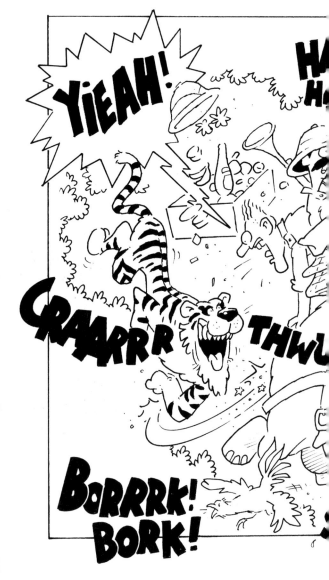

The size and arrangement of the lettering is varied to make the sounds more expressive. You can join or overlap letters for visual effect as long as they remain basically readable. Balloons add emphasis and show where particular sounds are coming from.

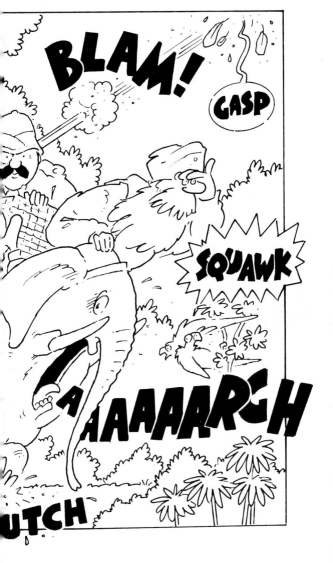

ACKNOWLEDGEMENTS

Series editor: Judy Martin
Art direction: Peter Owen